Celtic Blessings

A Coloring Book to Bless and De-Stress

PARACLETE ·PRESS

PARACLETE PRESS
BREWSTER, MASSACHUSETTS

2016 Third and Fourth Printing
2015 First and Second Printing

Celtic Blessings: A Coloring Book to Bless and De-Stress

Copyright © 2015 by Paraclete Press, Inc.

ISBN 978-1-61261-766-4

These designs were created by monastics from the Community of Jesus, an ecumenical monastic community rooted in the Benedictine tradition.

The Paraclete Press name and logo (dove on cross) are trademarks of Paraclete Press, Inc.

10 9 8 7 6 5 4

Published by Paraclete Press
Brewster, Massachusetts
www.paracletepress.com

Printed in the United States of America

\mathcal{S}ometimes coloring is just coloring. To put crayons to paper and create a rainbow of marks and swaths is relaxing, playful, and maybe even artistically satisfying. But sometimes coloring is more. To put colored crayons, markers, or pencils to paper is to create a pathway to the numinous. Coloring invites the body and the senses into an experience of inner stillness. While the hand moves, the mind and the body slow down. The heart and the ears open carving a space for rich silence and an opportunity for God to speak.

—SYBIL MACBETH,
author of *Praying in Color: Drawing a New Path to God*

May your day be filled
with blessings
Like the sun that lights
the sky.

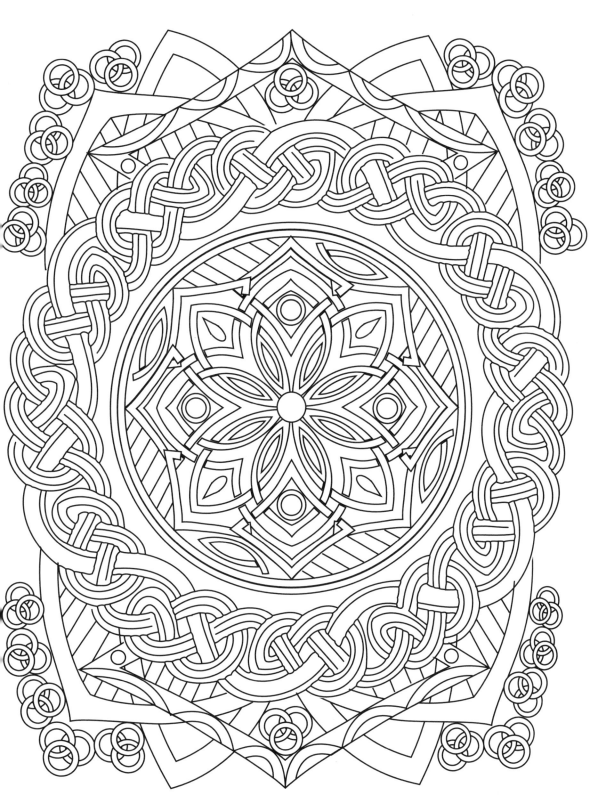

May the Lord keep you
in his hand.

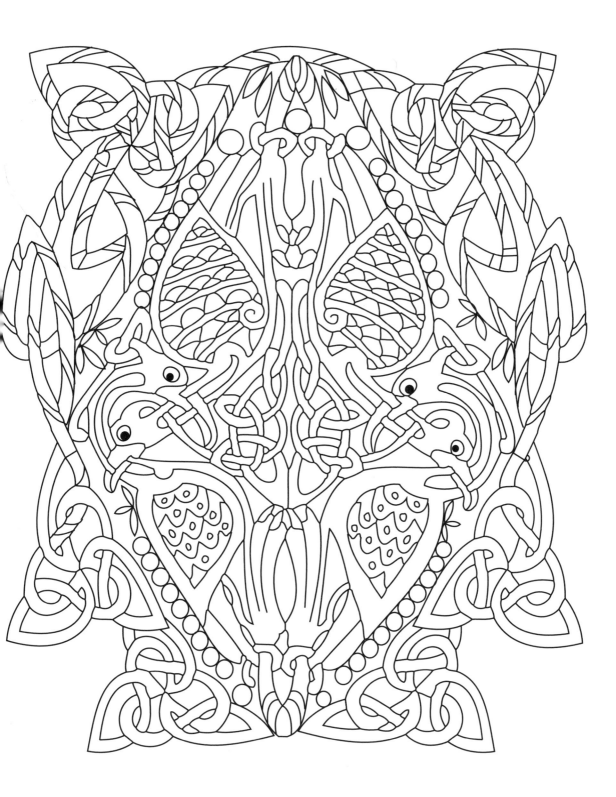

Bless to me, O God,
Each sound my ear
hears.

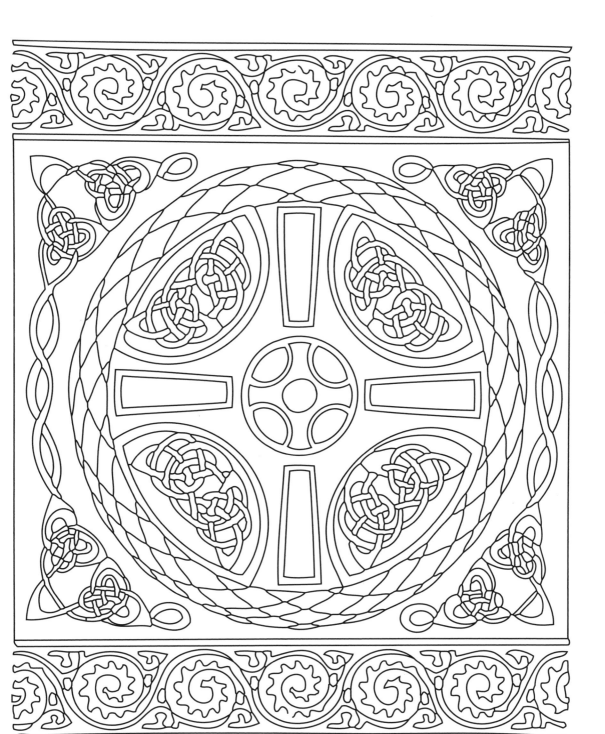

May the sun shine
Warm upon your face.

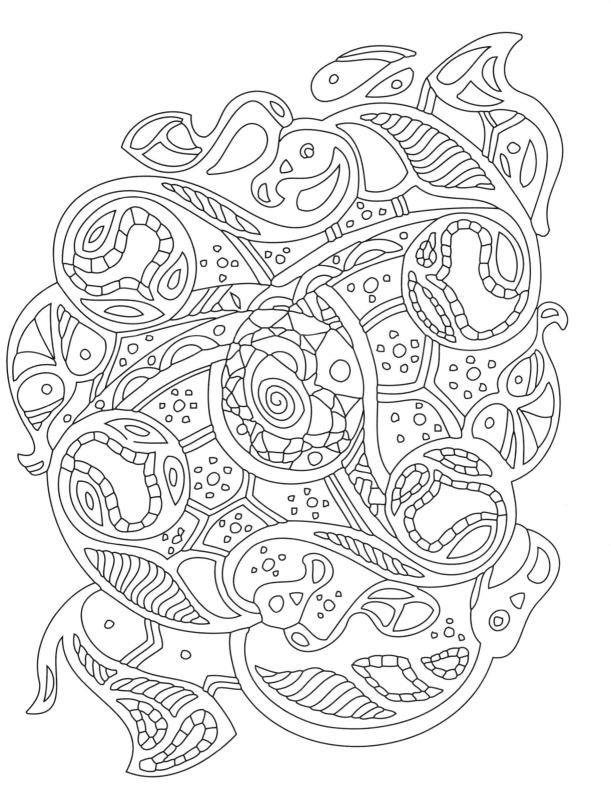

May the road
Rise to meet you.

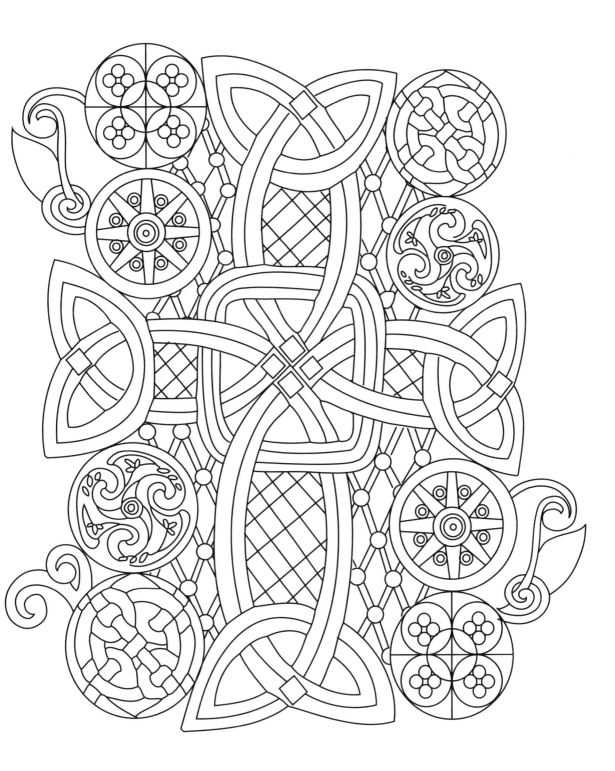

May the wind
Be always at your back.

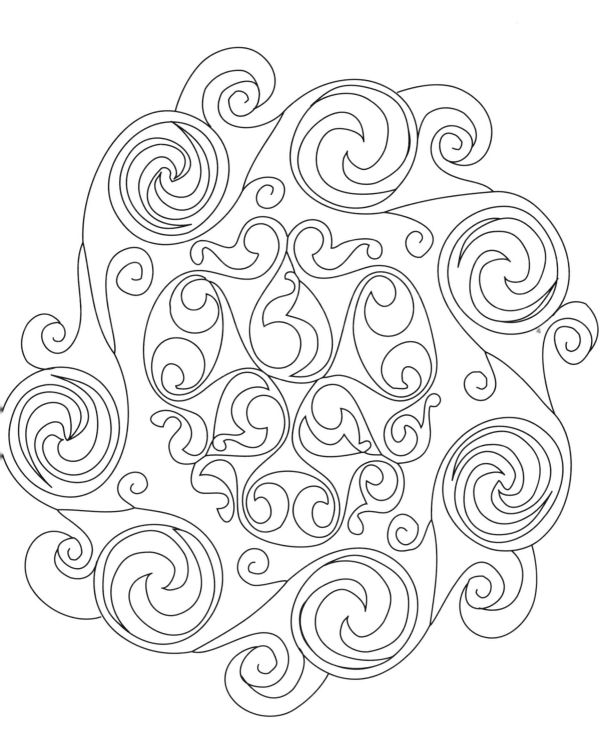

May your right hand
always
Be stretched out in friendship
And never in want.

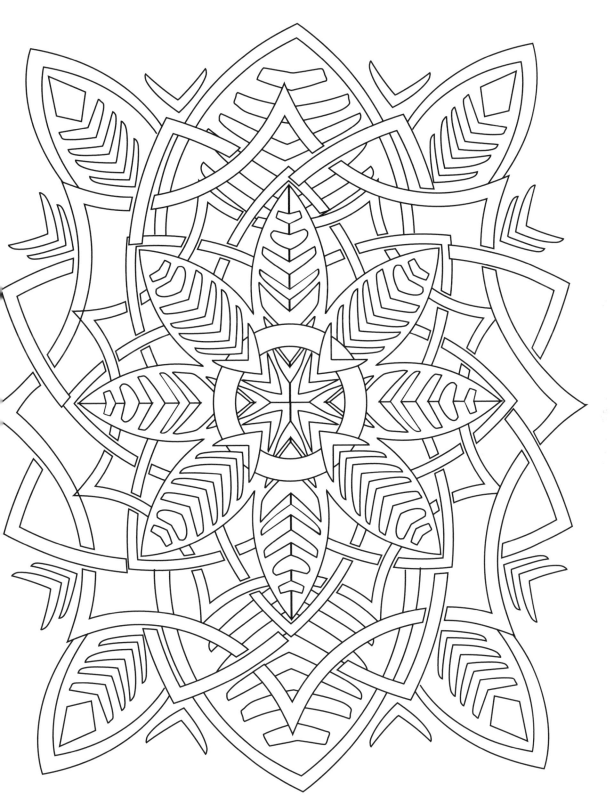

May the hand
of a friend
Always be near you.

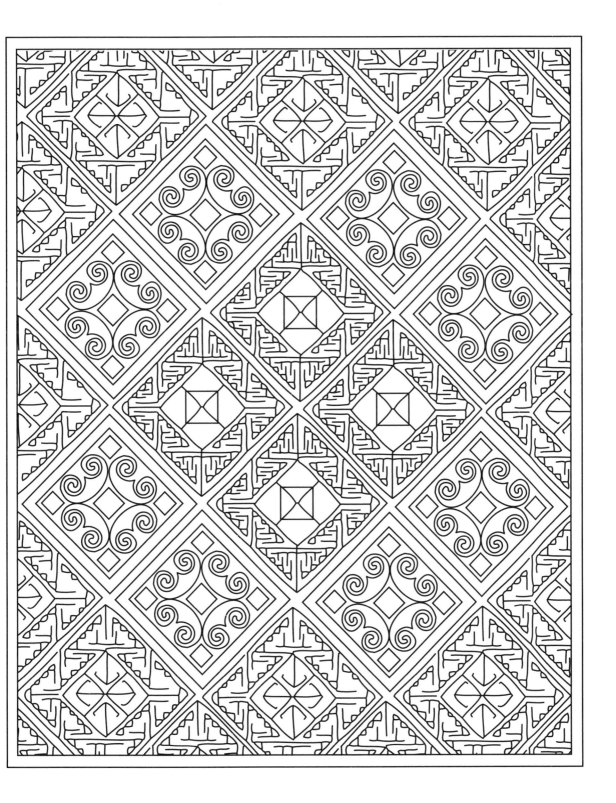

May your thoughts be
As glad as shamrocks.

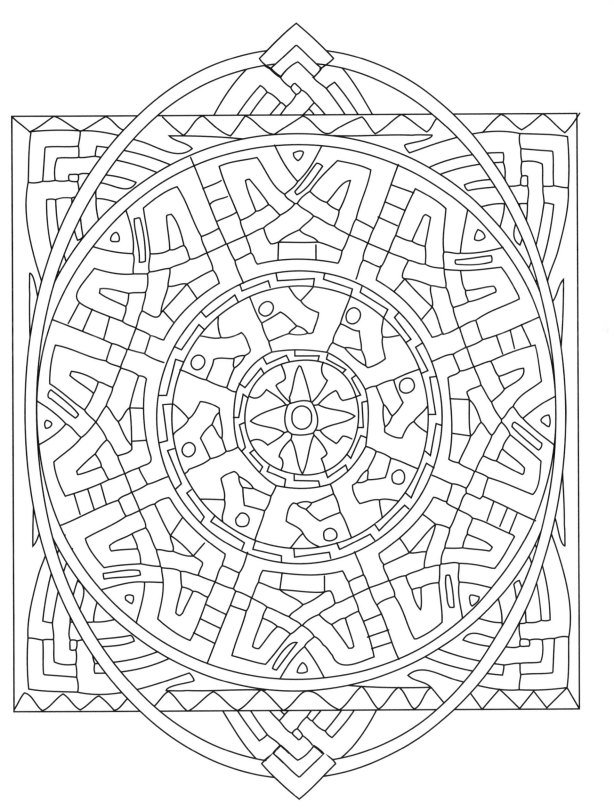

May you always have
the courage
To spread your wings
and fly!

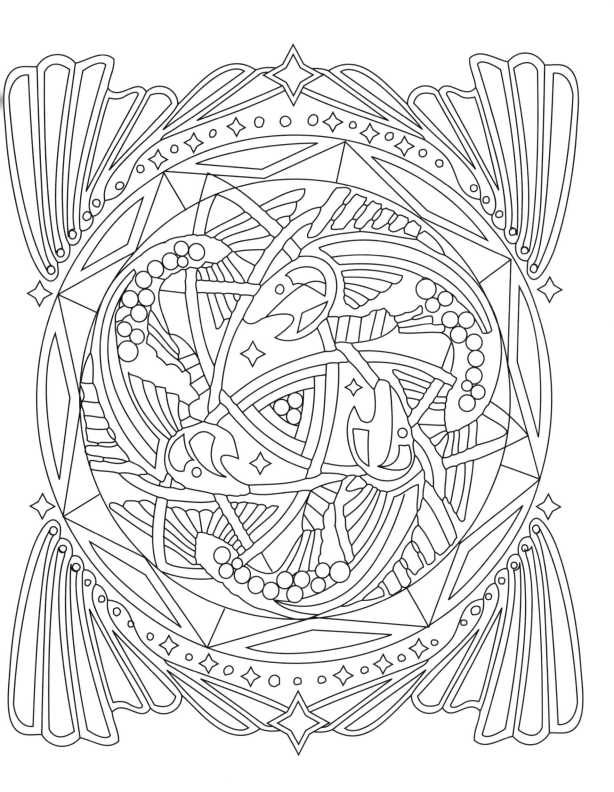

May the blessing of light be on you—
Light without and light within.

May the rains
Fall soft upon
your fields.

*May all life's
passing seasons
Bring the best to you and
yours!*

May the cool rain
quench your flower's thirst
And wash your troubles
away.

May the sun
shine bright on your
windowpane.
May the rainbow be
certain to follow each rain.

Bless you and yours
As well as the cottage
you live in.

May your blessings
outnumber
The shamrocks that grow.

*May your heart be
As light as a song.*

May you love
As though you have
never loved before.

May love and laughter
light your days,
And warm your heart
and home.

*May good and faithful
Friends be yours,
Wherever you may roam.*

May peace and plenty
bless your world
With joy that long
endures.

Good health, good luck,
and happiness
For today and every day.

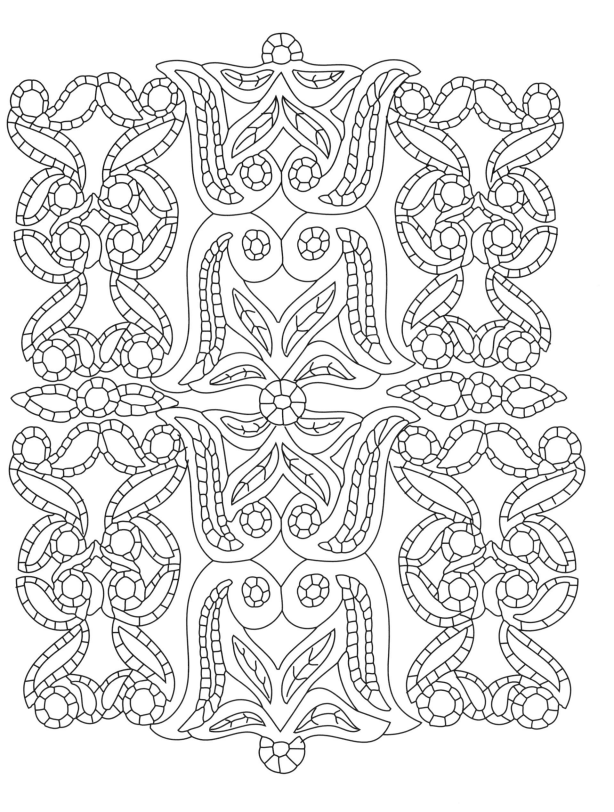

May those you love
bring love back to you
And may all the wishes
you wish come true!

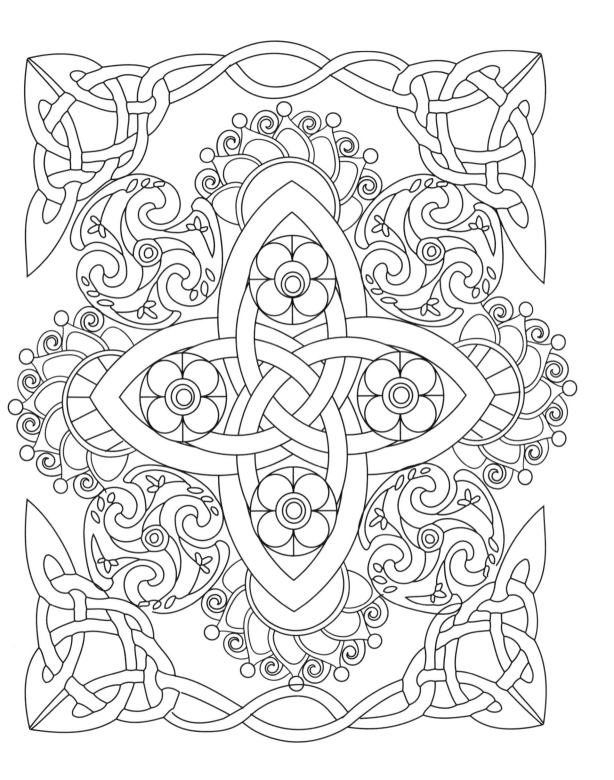

*May the smile of God
Light you to glory.*

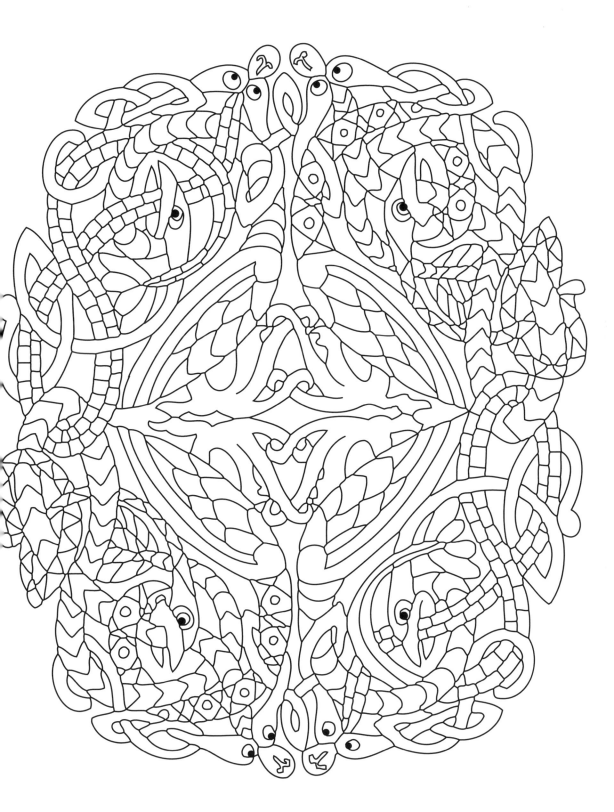

May God
and his angels
Be close at hand.

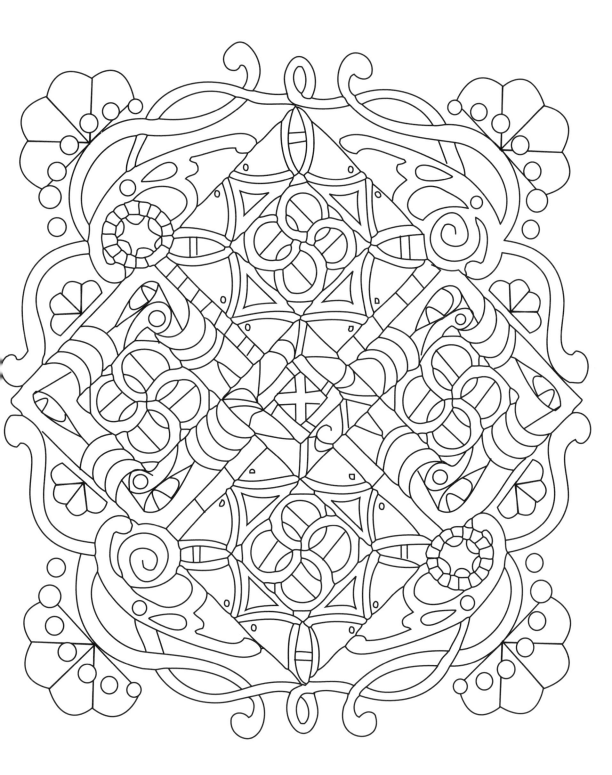

May God grant you
All that you need!

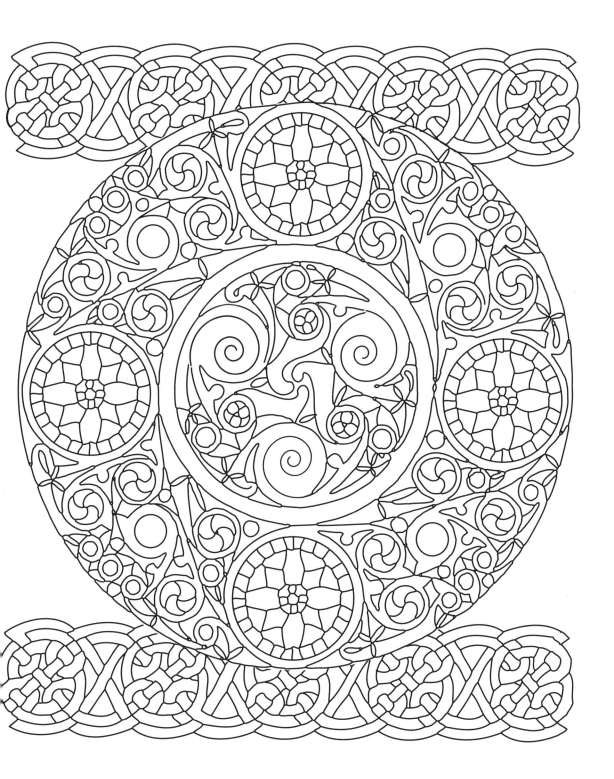

Peace between neighbors,
Peace between kindred,
In the love of the
King of life.

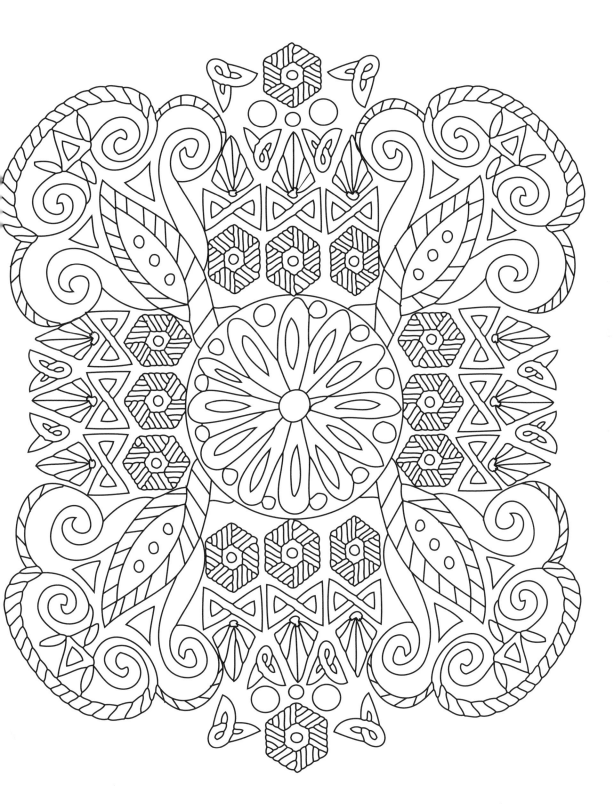

Until we meet again,
May God hold you in the
hollow of his hand.

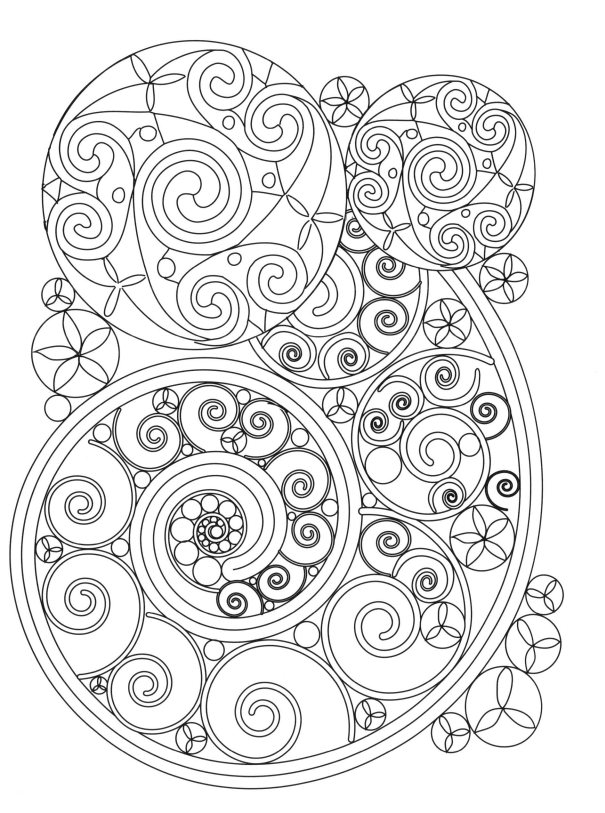

Learn about *Praying in Color* from Paraclete Press . . .

Praying in Color:
Drawing a New Path to God
Sybil MacBeth

ISBN: 978-1-55725-512-9, $17.99, Paperback

*M*aybe you hunger to know God better. Maybe you love color. Maybe you are a visual or kinesthetic learner, a distractible or impatient soul, or a word-weary pray-er. Perhaps you struggle with a short attention span, a restless body, or a tendency to live in your head. This prayer form can take as little or as much time as you have or want to commit, from 15 minutes to a weekend retreat. "A new prayer form gives God an invitation and a new door to penetrate the locked cells of our hearts and minds," explains Sybil MacBeth. "For many of us, using only words to pray reduces God by the limits of our finite words."

Use *Praying in Color* to help with:
• praying for others
• *lectio divina*—reading the Bible for spiritual growth
• memorizing Scripture
• prayers for discernment
• creating a personal Advent or Lenten calendar

"Just as Julia Cameron, in *The Artist's Way*, showed the hardened Harvard businessman he had a creative artist lurking within, MacBeth makes it astonishingly clear that anyone with a box of colors and some paper can have a conversation with God."—*Publishers Weekly*, starred review

Praying in Color:
Kids' Edition
Sybil MacBeth

ISBN: 978-1-55725-595-2, $16.99, Paperback

*N*ow kids can pray in color, too! This is prayer that makes sense to kids. One minute a day will do. Any time of the day will work. Drawing with markers or crayons is half the prayer; the other half is carrying the visual memories throughout the day.